D0178652

# How to Draw
# Comic Book Super Heroes
# Using 5 Easy Shapes

Steve Hilker

ISBN: 147006460X
ISBN-13: 978-1470064600

Copyright © 2012 Steve Hilker
All rights reserved.

**Disclaimer:** The material presented is my original creation; any characters not created by myself are in no way official nor endorsed by their owners. They are either trademarks or registered trademarks of their owners in the United States and/or other countries.

# Contents

# You Just Need 5 Simple Shapes

Line

———

Rectangle

Triangle

Circle

Arc

# How to use this book

This book teaches kids how to draw their favorite super heroes using simple shapes they already know how to draw or can quickly learn.

All of the super heroes start with the same body.  We show you how to draw it step-by-step on Page 7.

The shape(s) to be drawn will be shown in RED on the right side of the page.

After you have drawn what's shown in Step 1, go to Step 2.

Step 1:   Draw a rectangle for the head

Step 2:   Add the neck using a small rectangle

In Step 2, you will see Step 1 repeated, but shown in BLACK.  The new part(s) to be drawn, printed in RED, is Step 2.

Occasionally part of a shape used will need to be erased.  If so, these will be shown as dotted BLUE lines.

You will follow this method for every step.  Some steps will have more than one thing for you to do:

Step 3:  Daredevil's Suit

- Draw 2 overlapping D's to make the Daredevil symbol

- Draw 2 lines to make belt

- Draw lines on each leg for Daredevil's boots

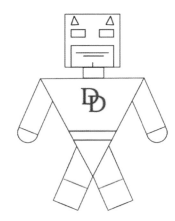

It's not hard.  Just follow each item in order using your 5 shapes.

It's time to get some paper, practice your shapes and start putting them together to make a body.

Soon you'll know the steps for making a body by heart and you'll be able to draw all of your favorite characters – and even begin creating your own!

# How to draw the body

**Step 1:**   Draw a rectangle for the head

**Step 2:**   Add the neck using a small rectangle

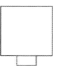

**Step 3:**   Add the chest using a large triangle

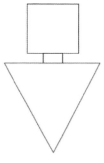

**Step 4:**   Add arms using rectangles
        Add hands using arcs

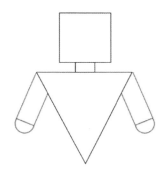

**Step 5:**   Add legs using rectangles

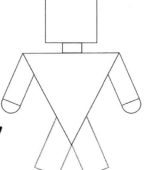

**CONGRATULATIONS!  YOU'RE NOW
READY TO DRAW A SUPER HERO!**

7

# BATGIRL

## Step 1:  Draw a body

- Draw 2 lines to shape face
- Erase dotted BLUE lines to make a girl face

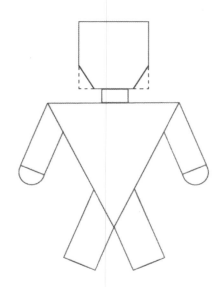

## Step 2:  Batgirl's Face & Mask

- Draw 2 triangles for the mask's ears
- Draw 2 arcs and 2 circles for eyes
- Draw 2 lines and 2 arcs to make Batgirl's hair
- Draw 3 arcs to make lips
- Draw 2 triangles over each eye.  Erase dotted BLUE line between them.
- Draw 2 triangles for bottom of mask. Erase dotted BLUE line between them.

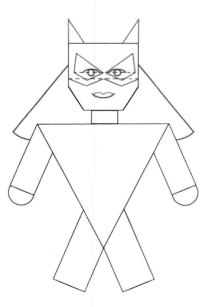

**continue to step 3 on next page ...**

## Step 3: Batgirl's Suit

- Draw 2 triangles and 1 line on each arm for gloves

- Draw 1 line on each leg for boots

- Draw arcs for bats on chest and belt

- Draw lines to finish belt

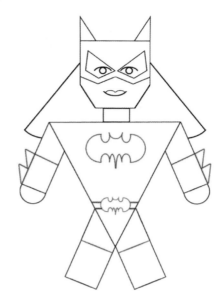

## Step 4: Batgirl's cape

- Draw lines and arcs for cape

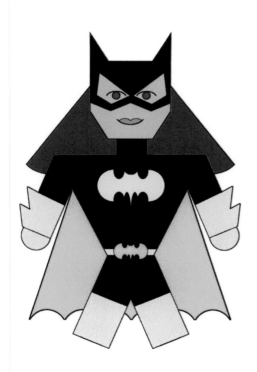

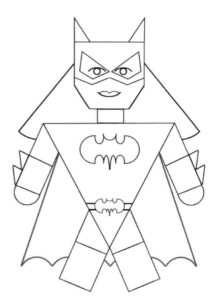

# BATMAN

## Step 1: Draw a body

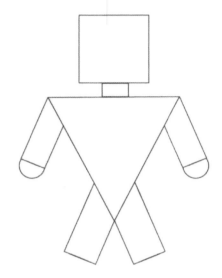

## Step 2: Batman's Mask

- Draw 2 triangles for mask's ears
- Draw 2 rectangles for mask's eyes
- Draw 2 circles and lines for eyes
- Draw rectangle for mask's mouth area
- Draw triangle for mask's nose
- Draw lines for Batman's mouth and chin

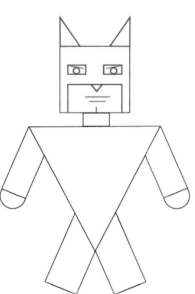

**continue to step 3 on next page ...**

## Step 3: Batman's Suit

- Draw two arcs to make an oval for Batman's chest symbol
- Draw 5 triangles to make bat
- Draw 2 lines to make belt
- Draw circle for belt buckle
- Draw two triangles on each arm for Batman's gloves
- Draw lines on each arm and leg for Batman's gloves and boots

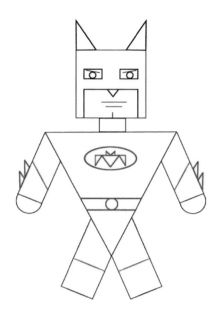

## Step 4: Batman's Cape

- Draw two rectangles for top of Batman's cape
- Draw lines and arcs to finish cape

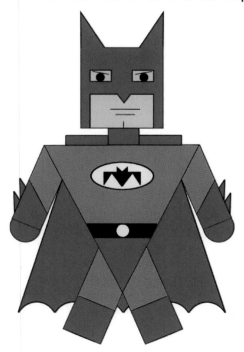

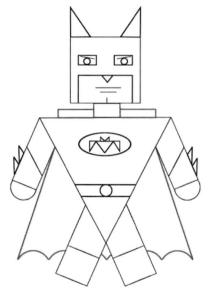

11

# CAPTAIN AMERICA

## Step 1:  Draw a body

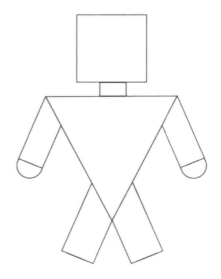

## Step 2:  Captain America's Mask

- Draw two rectangles for ears
- Draw rectangle for mask's mouth area
- Draw two rectangles for mask's eyes
- Draw two circles and lines for eyes
- Draw lines for mouth and chin
- Draw an "A" on top of mask
- Draw two rectangles and two triangles for mask's wings

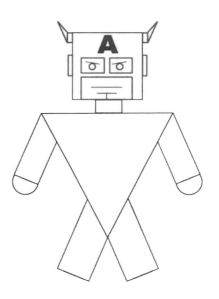

**continue to step 3 on next page ...**

## Step 3: Captain America's Suit

- Draw three triangles to make a star
- Draw two lines to make belt
- Draw rectangle for belt buckle
- Draw lines for flag stripes
- Draw lines on each arm and leg for Captain America's arm stripes, gloves and boots

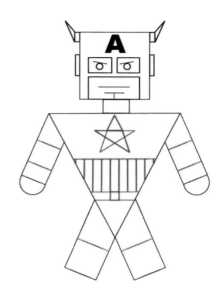

## Step 4: Captain America's Shield

- Draw a circle for shield
- Erase hand behind shield
- Draw 3 circles for shield stripes
- Draw 3 triangles to make star on shield

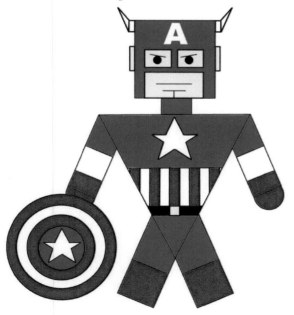

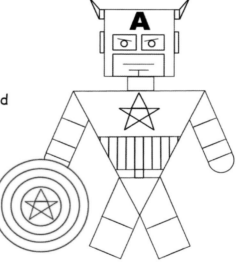

# CYCLOPS

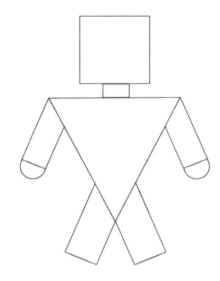

**Step 1:  Draw a body**

**Step 2:  Cyclops's Mask**
- Draw large rectangle for visor
- Draw thin rectangle for laser eye slot
- Draw 2 rectangles for ear covers
- Draw rectangle for mask's mouth area
- Draw triangle for visor's nose area
- Draw lines for Cyclops's mouth and chin
- Erase dotted BLUE line for visor nose area

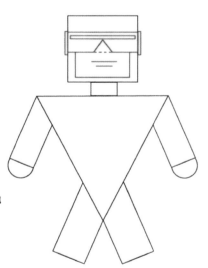

**continue to step 3 on next page ...**

## Step 3:  Cyclops's Suit

- Draw 2 lines to make belt
- Draw rectangle for belt buckle
- Draw an "X" in belt buckle
- Draw two rectangles on each side of the belt buckle for pouches.
- Draw circles for snaps on each pouch
- Draw lines on each arm and leg for Cyclops's gloves, boots and leg bands

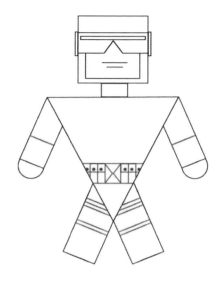

## Step 4:  Cyclops's Chest Belt

- Draw two circles and an "X"
- Draw thin rectangles for straps

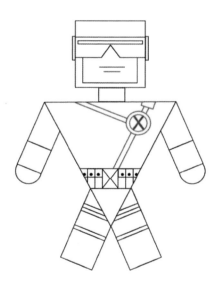

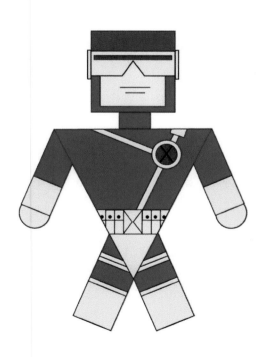

15

# DAREDEVIL

## Step 1:  Draw a body

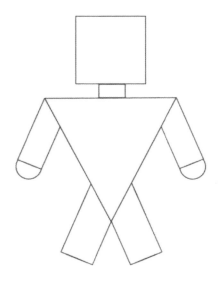

## Step 2:  Daredevil's Mask

- Draw 2 triangles for mask's horns
- Draw 2 rectangles for mask's eyes
- Draw rectangle for mask's mouth area
- Draw lines for Daredevil's mouth and chin

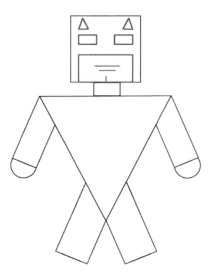

**continue to step 3 on next page ...**

## Step 3:  Daredevil's Suit

- Draw 2 overlapping D's to make the Daredevil symbol

- Draw 2 lines to make belt

- Draw lines on each leg for Daredevil's boots

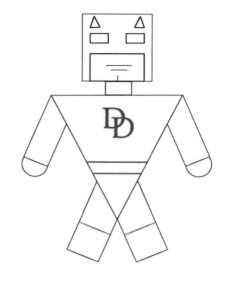

## Step 4:  Daredevil's club

- Draw a rectangle on right leg for club holder

- Draw a line and arc to create club

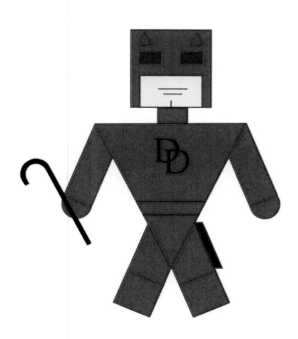

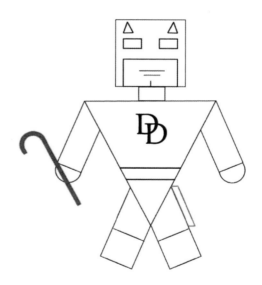

# ELEKTRA

## Step 1: Draw a body

- Draw 2 lines to shape face
- Erase dotted BLUE lines to make a girl face

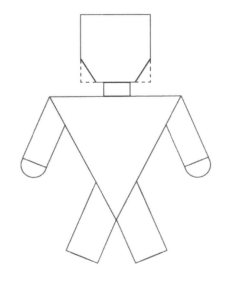

## Step 2: Elektra's hat and face

- Draw 3 lines and two triangles for Elektra's bandanna
- Draw 2 arcs and 2 circles for eyes
- Draw 2 lines for nose
- Draw 3 arcs for lips
- Draw 2 lines and 2 arcs to make Elektra's hair

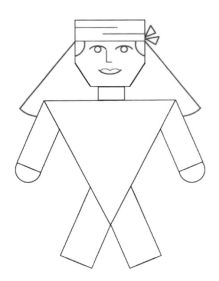

**continue to step 3 on next page ...**

## Step 3: Elektra's Suit

- Draw 4 arcs and a line to make Elektra's top

- Draw 2 lines to make belt

- Draw lines on each arm and leg for Elektra's wraps

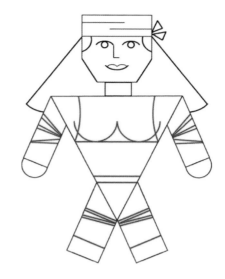

## Step 4: Elektra's knives

- Draw a long, skinny triangle and arc for each knife

- Color in the bottom of each knife to make a handle

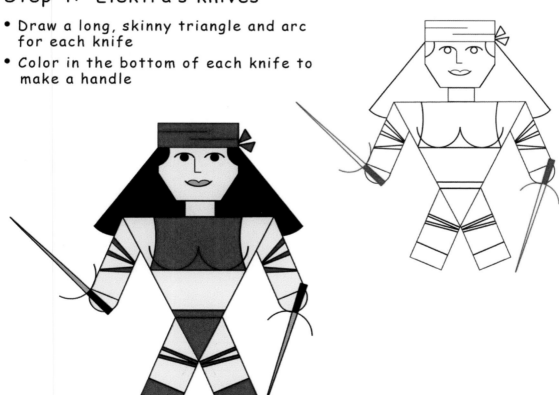

# The Flash

## Step 1:  Draw a body

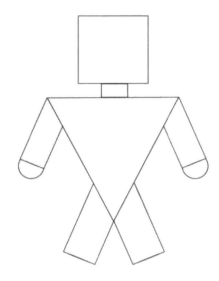

## Step 2:  Flash's Mask

- Draw two rectangles and two triangles for mask's lightening bolts
- Draw rectangle for mask's mouth area
- Draw two triangles in mouth area
  Erase dotted BLUE lines
- Draw two rectangles for mask's eyes
- Draw two circles and lines for eyes
- Draw lines for mouth and chin

**continue to step 3 on next page ...**

## Step 3:  Flash's Suit

- Draw four angled rectangles for belt
- Draw a line on each leg for boots
- Draw two rectangles and two triangles to make lightening bolts on each boot

## Step 4:  Flash's Chest & Arm Symbols

- Draw a circle in center of chest
- Draw two triangles and an angled rectangle to make the lightening bolt
- Draw a lightening bolt on each arm

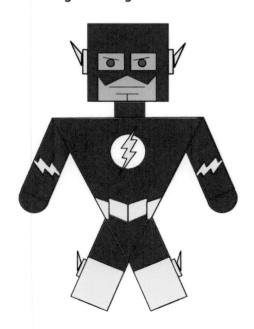

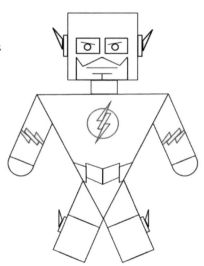

# GHOST RIDER

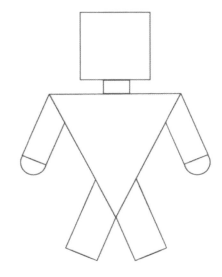

## Step 1: Draw a body

## Step 2: Ghost Rider's Skull

- Draw 2 thick triangles for eyes
- Draw 2 triangles and a line for nose
- Draw rectangle and lines for mouth
- Draw 2 triangles on each side of mouth
- Draw arc under mouth for chin
- Draw 3 lines between eyes for brow
- Draw LOTs of triangles on top and side of head for fire

**continue to step 3 on next page ...**

## Step 3: Ghost Rider's Suit

- Draw 2 triangles for jacket lapels
- Draw lines on edge of triangles for zipper
- Draw rectangle and circle below triangles for zipper pull tab
- Draw 2 lines for large belt. Add circles and lines for holes and buckle
- Draw 2 lines for small belt. Add dots and lines for holes and buckle
- Draw rectangle and lines behind belts for jacket zipper
- Draw triangles and lines on arms, legs, and shoulders for spikes

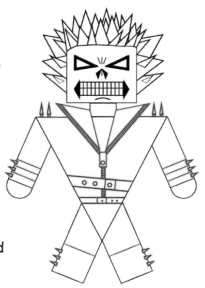

## Step 4: Ghost Rider's chain

- Draw arcs connected to one another to make chain links

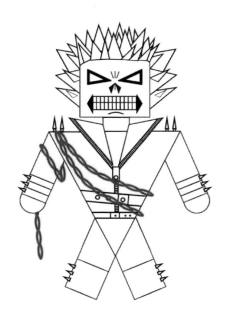

23

# GREEN LANTERN

**Step 1:  Draw a body**

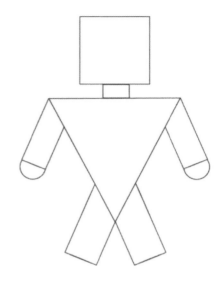

**Step 2:  Green Lantern's Face & Mask**

- Draw rectangle for mask
- Draw 2 small rectangles for eyes
- Draw 2 rectangles for ears
- Draw 3 arcs for hair
- Draw triangle for mask's nose
- Draw lines for mouth and chin

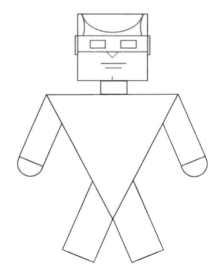

**continue to step 3 on next page ...**

## Step 3:  Green Lantern's Suit

- Draw a triangle on top of each arm
- Draw a triangle on each side of chest
- Draw a triangle on neck
- Draw a large triangle in middle of chest
- Draw two triangles on each leg
- Erase dotted BLUE lines

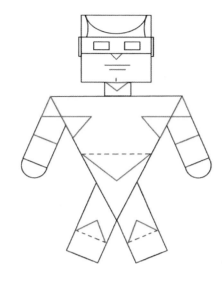

## Step 4:  The Lantern

- Draw a circle on chest
- Draw a circle inside the larger circle
- Draw 2 thick lines on the smaller circle
- Draw a small lantern on the hand for his ring

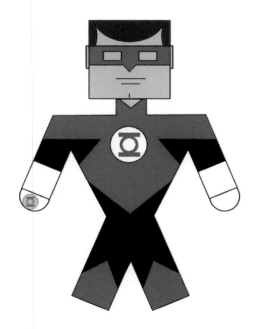

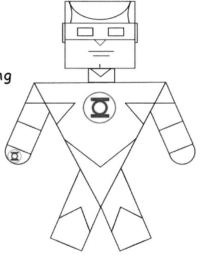

# HULK

## Step 1:  Draw a body

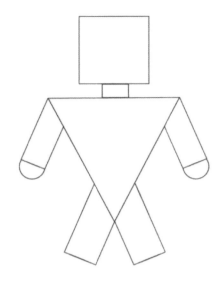

## Step 2:  Hulk's Face

- Draw 7 triangles for hair
- Draw 2 rectangles for ears
- Draw 2 circles for eyes
- Draw thick lines for eye brows
- Draw large rectangle for mouth
- Draw 5 lines inside rectangle for teeth
- Draw 1 thick line in mouth
- Draw 2 triangles on each side of mouth

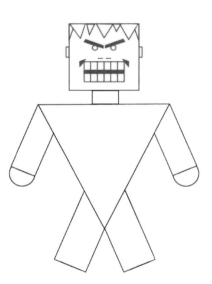

**continue to step 3 on next page ...**

## Step 3:  Hulk's pants

- Draw a line for top of Hulk's pants

- Draw 4 triangles on each leg

- Erase dotted BLUE line on each leg

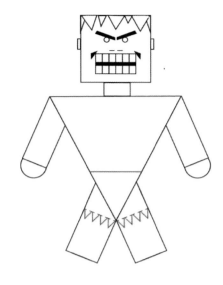

## Step 4:  Hulk's muscles

- Draw a large rectangle on chest
- Erase dotted BLUE line
- Draw a line in center of rectangle
- Draw 6 rectangles for stomach muscles

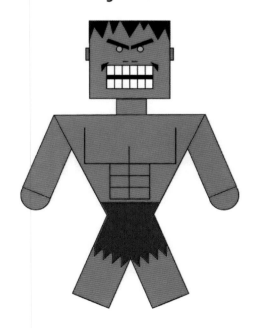

# IRON MAN

## Step 1:  Draw a body

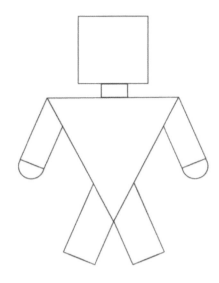

## Step 2:  Iron Man's Mask

- Draw a rectangle at top of the head
- Draw 2 rectangles down each side of the head
- Draw a triangle below top rectangle
- Draw thick lines for eyes holes
- Draw thick line for mouth
- Draw 2 rectangles for ears
- Erase dotted BLUE lines from top rectangle

**continue to step 3 on next page ...**

## Step 3: Iron Man's Arms & Legs

- Draw a rectangle on neck
- Draw a triangle at top of each arm
- Draw a rectangle on each arm
- Draw a rectangle on each leg
- Erase dotted BLUE lines

## Step 4: Iron Man's Suit

- Draw 2 circles on chest
- Draw arcs on each hip
- Draw a triangle and lines for pants
- Erase dotted BLUE lines

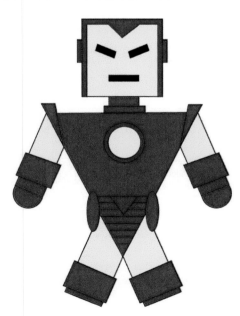

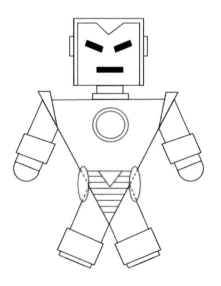

# ROBIN

## Step 1:  Draw a body

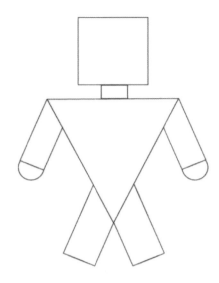

## Step 2:  Robin's Face & Mask

- Draw rectangle for mask
- Draw 2 small rectangles & circles for eyes
- Draw 2 rectangles for ears
- Draw 3 arch for hair
- Draw lines for mouth

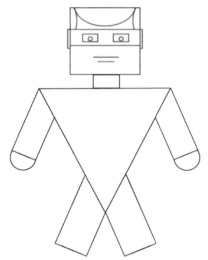

**continue to step 3 on next page ...**

## Step 3: Robin's Suit

- Draw 2 lines on each arm
- Draw a triangle on each arm for glove
- Draw 2 lines and rectangle for belt
- Draw a line on each leg for vest bottom
- Draw a "V" on each leg for boots
- Draw 7 lines on chest for buttons

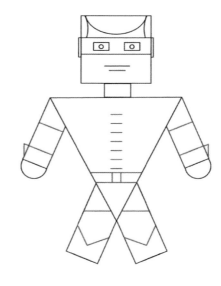

## Step 4: Robin's Cape and "R"

- Draw 2 rectangles for top of cape
- Draw lines behind body for cape
- Draw a circle and "R" on chest

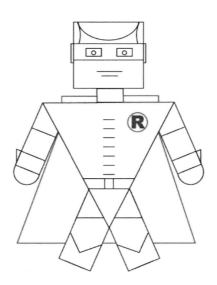

# SPIDER-MAN

Step 1:  Draw a body

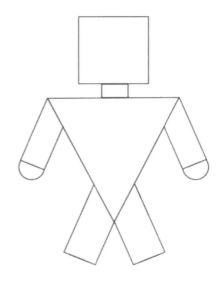

Step 2:  Spider-Man's Mask
- Draw 2 thick triangles for eyes
- Draw lines and arcs for web

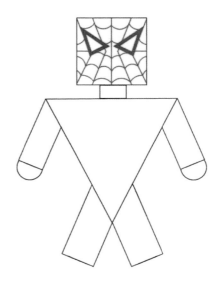

**continue to step 3 on next page ...**

## Step 3:  Spider-Man's Suit

- Draw 2 lines across stomach for belt
- Draw a rectangle above the belt
- Draw lines from rectangle to each arm pit
- Draw rectangles on each arm
- Draw lines on each leg for boots
- Erase dotted BLUE lines

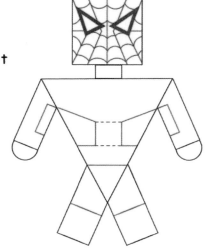

## Step 4:  Spider-Man's Spider & Web

- Draw 4 arcs to make the spider's body
- Draw 8 lines for spider's legs
- Draw lines and arcs for webbing

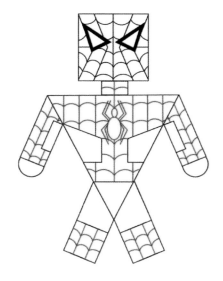

# STORM

## Step 1:  Draw a body

- Draw 2 lines to shape face
- Erase dotted BLUE lines to make a girl face

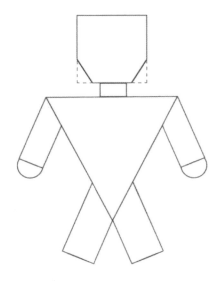

## Step 2:  Storm's Face & Hair

- Draw a circle for center of head band
- Draw 2 lines from each side of circle for head band
- Draw a line on each side of face to complete the head band
- Draw a "V" under the circle for part of Storm's hair
- Draw 2 arcs for each eye
- Draw 2 lines for nose
- Draw 2 lines and 4 arcs to make Storm's hair
- Draw 3 arcs to make lips

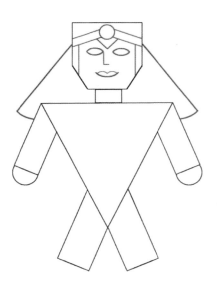

**continue to step 3 on next page ...**

## Step 3:  Storm's Suit

- Draw a circle at top of chest for button on Storm's cape
- Draw 4 arcs from cirlce for top of cape
- Draw small circle on stomach
- Draw a triangle above and below small circle
- Draw a line on each for wrist bands
- Draw a triangle on each leg for top of boots
- Erase dotted BLUE lines

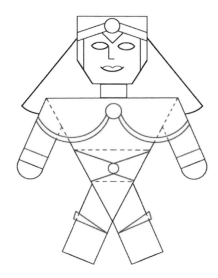

## Step 4:  Storm's Cape

- Draw 3 arcs on each side of Storm's body for her cape

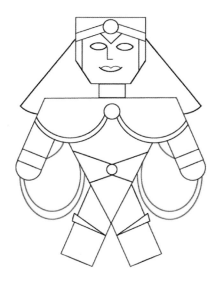

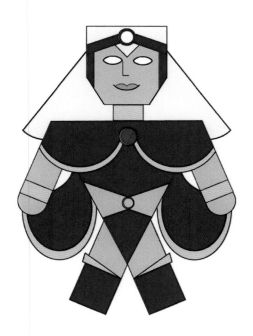

# SUPERGIRL

## Step 1: Draw a body

- Draw 2 lines to shape face
- Erase dotted BLUE lines to make a girl face

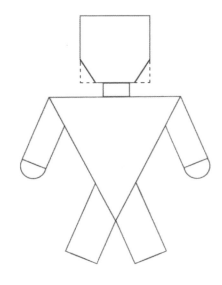

## Step 2: Supergirl's Face & Hair

- Draw 2 arcs and 2 circles for eyes
- Draw 2 lines for nose
- Draw 2 lines and 6 arcs to make Supergirl's hair
- Draw 3 arcs to make lips
- Draw 2 lines over each eye for eye brows

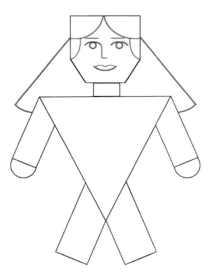

**continue to step 3 on next page ...**

## Step 3:  Supergirl's Suit

- Draw 3 triangles on chest
- Draw 2 arcs on chest
- Draw 4 lines for belt
- Draw 2 lines on each leg for boots
- Draw 2 triangles and 1 line for skirt
- Erase dotted BLUE lines

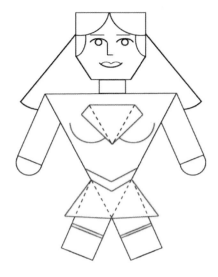

## Step 4:  Supergirl's Cape and "S"

- Draw 2 rectangles for top of cape
- Draw lines behind body for cape
- Draw an "S" on chest

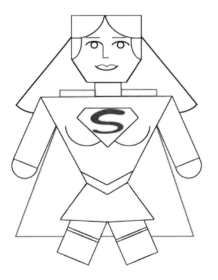

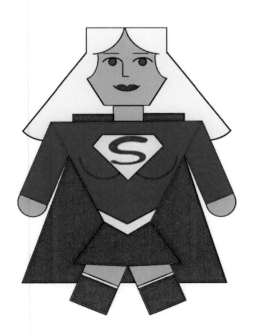

# SUPERMAN

**Step 1:  Draw a body**

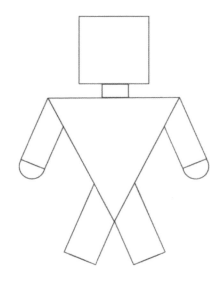

**Step 2:  Superman's Face**

- Draw 2 lines and 2 cirlces for eyes and eye brows
- Draw 2 rectangles for ears
- Draw 3 arcs for hair
- Draw lines for nose, mouth, and chin

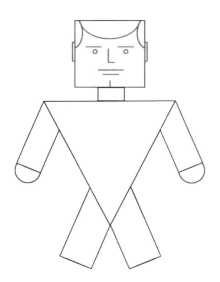

**continue to step 3 on next page ...**

## Step 3: Superman's Suit

- Draw 3 triangles on chest
- Draw 2 lines and rectangle for belt
- Draw a line on each leg for boots
- Erase dotted BLUE lines

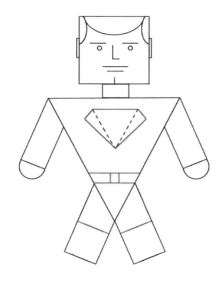

## Step 4: Superman's Cape and "S"

- Draw 2 rectangles for top of cape
- Draw lines behind body for cape
- Draw an "S" on chest

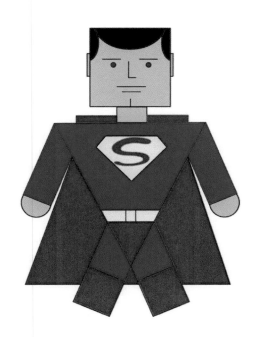

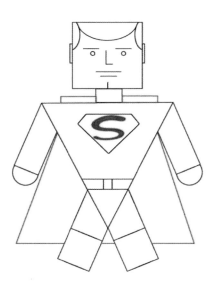

# THING

Step 1:  Draw a body

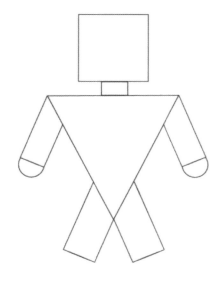

Step 2:  Thing's Face
- Draw a large rectangle for eyebrows
- Draw lines to divide eyebrow into rocks
- Draw 2 circles for eyes
- Draw small rectangle for nose
- Draw large rectangle for mouth and fill in
- Draw small rectangles around mouth
- Draw lines in rest of face for rocks

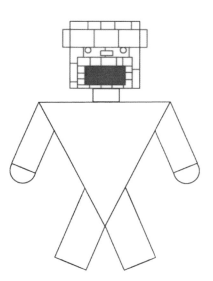

**continue to step 3 on next page ...**

## Step 3: Thing's pants

- Draw 2 lines for belt
- Draw a circle. Put a "4" inside it
- Draw a line on each leg

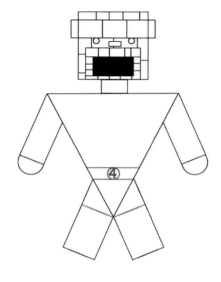

## Step 4: Thing's body

- Draw different sized rectangles over the entire body

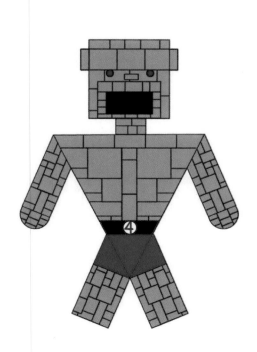

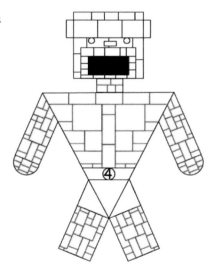

# THOR

## Step 1: Draw a body

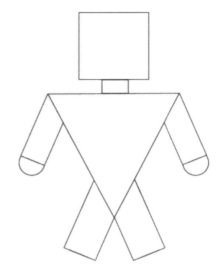

## Step 2: Thor's Face & helmet

- Draw 2 lines and 2 cirlces for eyes and eye brows
- Draw lines for nose, mouth, and chin
- Draw 2 lines across top of head for bottom of helmet
- Draw an arc over top of Thor's head for the top of his helmet
- Erase dotted BLUE line
- Draw 2 rectangles next to helmet
- Draw 2 triangles on each side of helmet for wings
- Draw 2 triangles and 2 lines for Thor's hair

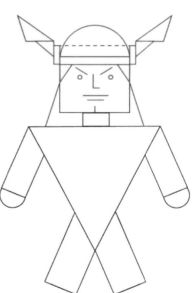

**continue to step 3 on next page ...**

42

## Step 3: Thor's Suit

- Draw 2 large and 2 small circles on chest
- Draw 2 lines for belt
- Draw circle and triangles for belt buckle
- Draw a "T" on belt buckle
- Draw a triangle on each leg for top of Thor's boots
- Draw 3 lines on each arm for wrist bands

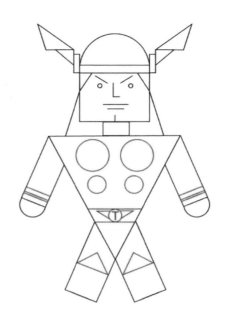

## Step 4: Thor's Cape and hammer

- Draw lines up from hair and behind Thor to make a cape
- Draw 3 rectangles to make a hammer
- Draw 2 arcs for hammer strap

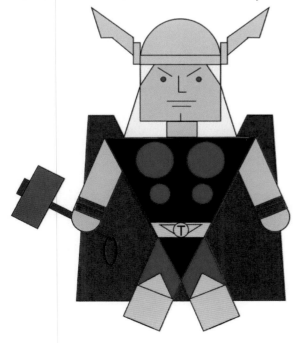

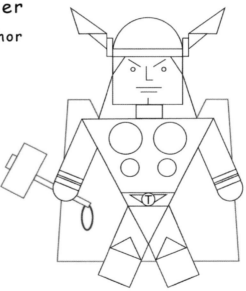

# WOLVERINE

## Step 1: Draw a body

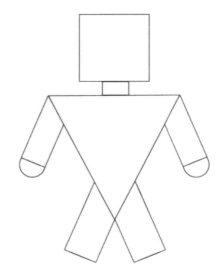

## Step 2: Wolverine's Face & Mask

- Draw rectangle for mask mouth area
- Draw 2 small rectangles for eyes
- Draw 2 triangles for nose
- Draw 2 large triangles for mask's ears
- Draw 2 small triangles to complete mask's ears
- Draw lines for mouth and chin
- Erase dotted BLUE lines

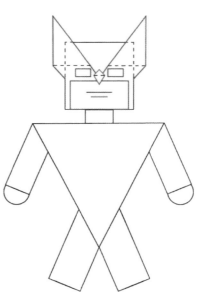

**continue to step 3 on next page ...**

## Step 3: Wolverine's Suit

- Draw 2 triangles on top of each arm
- Draw 2 triangles on top of chest
- Draw 3 triangles on each side of chest
- Draw 2 lines and 2 rectangles for belt
- Draw two lines on each arm for gloves
- Draw two triangles and 2 lines on each leg for boots
- Erase dotted BLUE lines

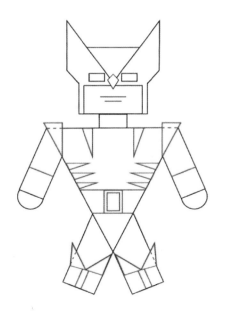

## Step 4: Wolverine's claws

- Draw 3 long triangles on each hand

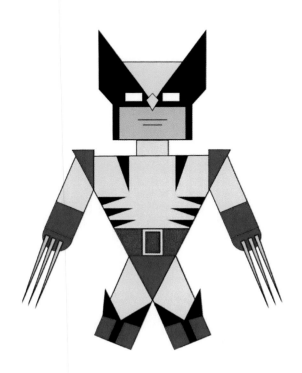

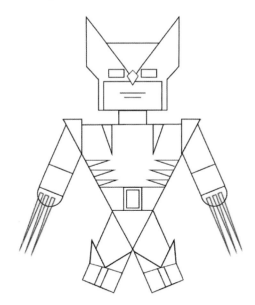

# WONDER WOMAN

## Step 1:  Draw a body

- Draw 2 lines to shape face
- Erase dotted BLUE lines to make a girl face

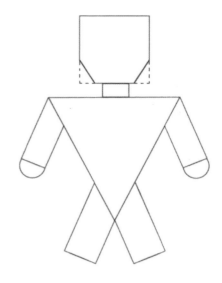

## Step 2:  Wonder Woman's Face & Hair

- Draw 2 triangles for head band
- Draw 2 arcs and 2 circles for eyes
- Draw 2 lines for nose
- Draw 2 lines and 4 arcs to make Wonder Woman's hair
- Draw 3 arcs to make lips
- Erase dotted BLUE lines

**continue to step 3 on next page ...**

## Step 3: Wonder Woman's Suit

- Draw a line on each arm for bands
- Draw 4 arcs for belt
- Draw 6 arcs on each side of chest
- Draw lines to connect arcs to make a "W" symbol
- Draw 4 lines on each leg for boots

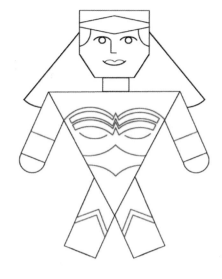

## Step 4: Stars & Lasso

- Draw three triangles to make a star
- Draw one star on head band and 3 stars on pants
- Draw 6 arcs to make lasso

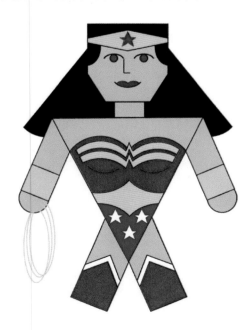

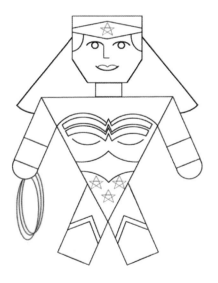

Printed in Great
Britain
by Amazon

32188748R00026